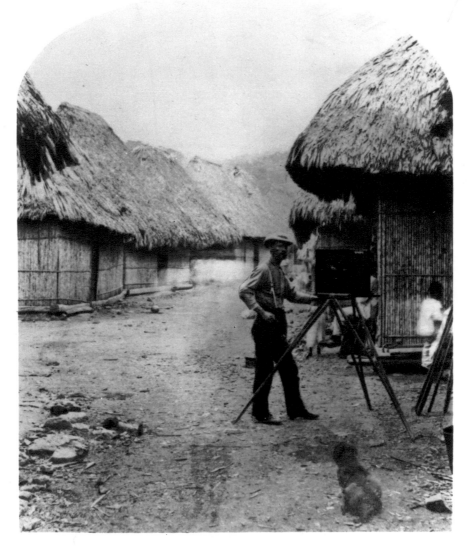

T. H. O'SULLIVAN PHOTOGRAPHER

by Beaumont and Nancy Newhall, with an appreciation by Ansel Adams

GEORGE EASTMAN HOUSE, IN COLLABORATION WITH THE AMON CARTER MUSEUM OF WESTERN ART

Published for members of THE GEORGE EASTMAN HOUSE in
collaboration with THE AMON CARTER MUSEUM OF WESTERN ART.
© 1966 by THE GEORGE EASTMAN HOUSE, INC., 900 *East Avenue,
Rochester, New York.*

All rights reserved, printed in the U.S.A.
Library of Congress Catalog Card Number: 66-25971

Designed by Nathan Lyons

Cover: Self portrait, Panama, U.S. Darien Expedition, at
Pinogana. 1870. Stereograph.

T. H. O'SULLIVAN

Beaumont and Nancy Newhall

Timothy H. O'Sullivan, who photographed the Civil War battlefield, the jungles and coast of Panama, and the deserts, plains, mountains, and canyons of the American West, was born in New York City in 1840.

He learned to photograph at the New York Gallery of Mathew B. Brady, and then in the branch managed by Alexander Gardner in Washington.

The outbreak of the Civil War was a trumpet call to Brady, who had long been interested in the value of photography as an historical record. "I felt I had to go. A spirit in my feet said 'Go,' and I went." On July 20, 1861, Brady set off from Washington with a couple of wagons full of journalists. Like the hordes of other civilians who were cluttering the road, he regarded the jaunt as a kind of overnight picnic with flags and bugles, and expected to accompany a victorious army to Richmond in the morning. What happened instead was the first Battle of Bull Run. Brady was caught in the rout—some wags later attributed the panic to his formidable-looking camera—and did his best to photograph the fugitives. The desperate flight jammed his wagons and damaged his equipment badly. A photograph shows him, haggard and wild-eyed, with a Zouave sword protruding from under his bedraggled duster, shorn of any idea that war was a picnic.

Here was his great chance to create a record in photographs, a vivid, living, and authentic history of the most terrible war America had known. His conception of photographing a war was infinitely broader than that of Roger Fenton, whose record of the Crimean War consists chiefly of empty battlefields and posed groups of soldiers. Brady had been in the thick of it. He believed everything the wet plates could catch should be photographed.

With vast campaigns forming, he realized that to photograph more than a fraction of the war himself was a physical impossibility. To make a great and full record, he must have many assistants. And so, "I had men in all parts of the army, like a rich newspaper." He organized them to travel in buggies that also served as darktents—for the wet plate process demanded that negatives be flowed, sensitized, exposed, and developed within fifteen minutes. As insurance against accidents, Brady instructed his men to make

two exposures of everything, whether they were making stereos, whole plates, or 8 x 10s.

"Brady's Photographic Corps," wrote the *New York World*, "heartily welcomed in each of our armies, has been a feature as distinct and omnipresent as the corps of balloon, telegraph, and signal operators. They have threaded the weary stadia of every march; have hung on the skirts of every battle scene; have caught the compassion of the hospital, the romance of the bivouac, the pomp and panoply of the field-review—aye, even the cloud of conflict, the flash of the battery, the afterwreck and anguish of the hard-won field."

O'Sullivan was one of the cameramen in this Photographic Corps of Brady's, working in the field alongside Alexander Gardner and his son, James. Brady gave no credit to his cameramen. Gardner protested: the photographers, he felt, should be allowed to copyright and sell pictures made on their own time and with their own equipment. In May, 1862, he left Brady to establish his own gallery in Washington, and to publish a series of "Photographic Incidents of the War" in competition with Brady. A catalogue was printed in September, 1863, of 568 titles. Gardner boasted that this was "the largest and finest collection of War Views ever made. Apart from the great interest appertaining to them, they stand unequalled as works of art. Amongst the contributors will be found the names of the most distinguished Photographers in the country."

When the war was over, Gardner published a two-volume *Photographic Sketch Book of the War*, containing one hundred original photographic prints. Forty-four of them were by O'Sullivan. They are among the most poignant of the thousands of photographs taken of the war.

He shows us artillery in action at Fredericksburg, 1863. Gardner wrote: "This picture was made as the guns were engaging the enemy, the gunners who had just received the order 'canoneers to your post,' calling to the photographer to hurry his wagon out of the way, unless he was anxious to figure in the list of casualties." He shows us the vast parks of wagons, pontoon bridges, camps. He shows us the dreadful aftermath: bloated corpses at Gettysburg darkening on the field, left by the retreating tide, under the weeping morning mist of July 4, 1863. Gardner commented in the *Sketch Book*: "Such a picture . . . shows the blank horror and reality of war, in opposition to its pageantry. Here are the dreadful details! Let them aid in preventing such another calamity falling upon the nation."

In 1867, O'Sullivan came West to join the first of the four great post-war surveys of the United States Government: the Geological Exploration of the 40th Parallel, led by Clarence King. This party, consisting of about seventeen civilians and their guard of cavalrymen, started from the huge East Wall of the Sierra Nevada on July 1, 1867, proposing to explore and document the still almost unknown wilderness stretching back from California along the known routes to civilization. No party led by the brilliant Clarence King could be dull, no matter how serious its purpose nor how interminable the ponderous volumes of its final report. Still in his twenties, King was not only a geologist, but a writer of wit and charm, a boon companion, and a daring mountaineer. Nor was the lean and agile O'Sullivan, who had cooly photographed through bombardments, any man to hang back when adventure offered.

They began with the wild Nevada mining towns— Virginia City, Gold Hill, and Silver City. O'Sullivan descended hundreds of feet down into the Great Comstock Lode, photographing its subterranean galleries by the light of burning magnesium. Then a few of the party decided to make the first descent of the Truckee River into Pyramid Lake. In one dangerous rapid the furious water jammed their sailboat between rocks, threatening wreck. O'Sullivan, a fine swimmer, plunged overboard and was hurled a hundred yards downstream. Breathless, torn, and battered, he crawled back along the shore, caught the rope his companions threw him, and warped the boat to safety. Arrived at last in the salt and stormy waters of the Lake, they found its "pyramid" islands indisputably inhabited by rattlesnakes.

Joining the rest of the Survey, they explored along the existing route of the overland stage and the proposed route for the railroad. Very soon they were in wild and unknown terrain, clawing and clambering their way through the splintered volcanic convulsions of the Humboldt Sink until driven out by mosquitos and fever. O'Sullivan had a helper

and two mules assigned to him; their heavy loads undoubtedly cost him dear when the Survey climbed up among the snows, lakes, and parks of the Rockies and crossed the divide at midnight, hoping the night chill had frozen a trustworthy crust on snowdrifts forty or fifty feet deep. Often men and animals broke through and sank out of sight in the treacherous slush.

As a rest from such exertions, O'Sullivan loaded his equipment into an ambulance drawn by four mules and departed a hundred miles south of the Carson Sink, where he photographed among dazzling white dunes that sometimes towered five hundred feet high, shifting contantly under the wind among whirling columns of sand.

In October, 1868, a small detachment including King and O'Sullivan were riding through a dreary waste of sagebrush when a throbbing underneath suddenly shook the air and the earth, and a fringe of black rocks appeared in the distance. Setting spurs to their mounts, King and O'Sullivan rode pellmell ahead, leaving others to bring up the supplies and cameras. Arriving on the brink of a vast gorge, they looked down at a majestic river roaring in multiple cascades down black Dantean chasms—the awesome Shoshone Falls of the Snake River. In this deep black canyon filled with deafening noise and towering mists, they spent ten days exploring and photographing.

In the three heavy volumes of mounted prints which O'Sullivan produced for King, there are photographs still unsurpassed in their bold and sensitive grasp of huge motifs. In all of them a masculine joy is felt. The strange beauty, the danger, and the freedom were a heady combination. Men grew to love this enormous savage earth where each rising or receding wave of mountains disclosed new worlds. They moved across deserts where naked hills, colored like metal, shimmered above alkali flats, and quiet plains dotted with sagebrush yawned suddenly into vast glowing canyons. Between bold mountain slides they found tender and enchanting meadows. Always, above and beyond, glittered the snow peaks.

Exploring and photographing was a life that became a passion; there was excitement in waiting for the snow on the passes to melt, in packing the animals with the results of a winter's ingenious planning, and setting off to carry scientific instruments into strange hells and paradises. Often all that was known of the regions ahead came from the incoherent mutterings of Indians and trappers, the crazed tales of survivors, or the discredited reports of earlier explorers who had no cameras or instruments to bear them out.

After three seasons as photographer with Clarence King, O'Sullivan was appointed Photographer to the Darien Surveying Expedition in 1870, by the Secretary of the Navy.

"You will proceed to New York and report to Lieut. Commander Thos. O. Selfridge, commanding U.S.S. 'Nipsic' and the expedition, for duty. While in the United States your pay will be at the rate of five dollars ($5.00) per day, and during the absence of the expedition,—from the date of sailing,—your pay will be at the rate of seven dollars ($7.00) per day. You will mess with the ward room officers and quarters, bedding and mess expenses will be found you by the government."

He sailed, not on the U.S.S. "Nipsic" but on the sistership "Guard" from New York City on Jan. 12, 1870. The purpose of the survey was to report to the government on possible routes for a ship canal between the Atlantic and Pacific Oceans. O'Sullivan managed to make and develop his wet plates in the steamy heat, moved cameras, tripods and darktent along trails newly hacked through the jungle and, occasionally, up into trees when a river suddenly rose several feet above the campsite. It was difficult to photograph in the jungle; O'Sullivan complained that the density of the foliage prevented him from making many pictures. Those published by the government in albums or as stereographs, neatly boxed, are mostly of the sea coast and villages with Indian life. He photographed himself in a native village, standing beside his 11 x 14 view camera.

In 1871 he returned to the West with the Geographical and Geological Explorations and Surveys West of the 100th Meridian, commanded by Lieutenant George M. Wheeler of the Corps of Engineers. That year the party went up the huge walled Owens Valley, crossed Death Valley in July, with the thermometer at midnight reading 109°F., and made their way to Camp Mojave with the intention of exploring *up* the Colorado River into the Grand Canyon. A sailboat

which was promptly christened the "Picture" was given over to O'Sullivan and his helpers and equipment, together with a roving commission. At first the journey was delightful. Then the current, as they approached the Grand Canyon, became more and more impassible. The difficult portage around Disaster Rapid took them six hours. In a whole day, the party advanced only two and three-quarter miles. Starvation Camp was a bitterly exact title; the following night, Wheeler, who kept the rations by him, found not enough left to make a decent pillow. "Mr. O'Sullivan," he reported, "in the face of all obstacles, made negatives at all available points, some of which were saved, but the principal ones of the collections were ruined during transportation from Prescott, Arizona, via the mouth of the Colorado, San Francisco, etc., to Washington, D. C., thus destroying one of the most unique sets of photographs ever taken."

In 1873 O'Sullivan, accompanying Wheeler further through Arizona and New Mexico, threaded the quicksands of the Canyon de Chelly and photographed the mysterious ruins of a dead race folded like swallow's nests into the hollow sides of precipices. These are among his most magnificent photographs.

In 1880 his bosom friend, Lewis Emory Walker, with whom he had been "associated . . . professionally for twenty-five years" died, leaving his position as photographer to the Treasury Department vacant. O'Sullivan applied for this post. He submitted to Secretary John Sherman an imposing list of sponsors, including Brady, who wrote that he had known O'Sullivan from boyhood: "He is a thorough expert at his business and a very reliable man." He got the job. But he was a sick man. His employment record comes to a close with the bald statement, "Removed March 31/81." He died of tuberculosis in Staten Island on January 14, 1882.

AN APPRECIATION

Ansel Adams

Photographers, like painters, often discover, through chance or serendipity, the immense importance of predecessors who may have long lain forgotten. Ansel Adams performed this service for Timothy H. O'Sullivan. In 1937, when asked to contribute to The Museum of Modern Art's first major show of photography, he sent with his own work a letter: "Dear Mr. Newhall: Following the mailing of my first letter to you today, I thought of something I have on hand here which might interest you as an item for exhibit. It is a collection of original prints, chiefly by a man named O'Sullivan, taken in the Southwest about 1870. A few of the photographs are extraordinary—as fine as anything I have ever seen." We gazed at the album with excitement, for the only photographs by O'Sullivan we knew were in Gardner's Sketch Book. The album was included in the exhibition. Later Adams presented it to The Museum of Modern Art in memory of his old friend Albert Bender.

B. & N.N.

Many years ago my good friend Francis P. Farquhar of San Francisco presented me with an album of original prints by Timothy H. O'Sullivan. The title page read (in part): *PHOTOGRAPHS . . . obtained in connection with Geographical and Geological Explorations and Surveys WEST OF THE 100th MERIDIAN, Seasons of 1871, 1872 and 1873. 1st Lieutenant Geo. M. Wheeler, Corps of Engineers, U.S. Army, in charge.* Up to that time I had seen few photographs of the American West of any consequence. I was weary of mere "record" photographs; while the subject matter might command interest the treatment was usually quite sterile and the quality poor.

The O'Sullivan photographs opened wide a new world for me. Here were perceptive images, well-composed, of high technical quality, and definitely suggesting a creative personality. The single-weight albumen prints were neatly mounted on horizontal album cards and the effort as a whole revealed excellent craftsmanship and respect for the medium.

These photographs were intended to present the "Landscapes, Geological and other Features" of important areas of the Southwest and were presumably directed to Congress, interested individuals and corporations; the development of the West was accelerating, and the Government Surveys resulted in general information of enormous value.

Perhaps O'Sullivan's finest photograph is his superb view of the Canyon de Chelly, Arizona, an image of great power and revelation. The limitations of the old wet plates were severe, but their color-blindness (they were sensitive only to the blue region of the spectrum) was most favorable to the rendition of the red rock of the Southwest.

O'Sullivan caught the majestic tonalities and, to a surprising degree, the impression of blazing light. The latter quality is due, again, to the blue-sensitive emulsion; the skies are very light and the feeling of recessive space is most convincing. There is a particular picture taken in the Black Canyon of the Colorado River; a small boat and figure, brooding cliffs and the sky full of air and light. No modern photographs I have seen so successfully convey the mood of such noble scenes.

Among the many images I recall with excitement is one of an inscription in Spanish carved in the stone of Inscription Rock, New Mexico ("Historic Spanish Record of the Conquest"). Beneath the inscription, supported on the spikes of a yucca plant against the stone, lies a black yardstick with white lines and figures. The unreality of this very real picture, enhanced by a marvelous tonality, suggests to me the vision of a Strand or a Weston—a vision not expected in a pioneer explorer-photographer in the rugged West of the 1870's.

O'Sullivan's work has a very important place in the history of the world's best photography.

ILLUSTRATIONS

O'Sullivan's photographs of the Civil War were published by Alexander Gardner as separate, mounted pictures. A selection of 44 appeared in the *Photographic Sketch Book of the Civil War*. His photographs of Panama and the U.S. West were published by the U.S. Government: the 10¾ by 7¾-inch prints separately and bound into handsome volumes; the stereographs boxed in sets. We have transcribed the captions exactly as they appear; editorial notes are enclosed in square brackets.

Civil War

1. Guard Mount, Headquarters Army of the Potomac. 1864.

2. View on the Appomattox River. 1865.

3. Pontoon Bridge Across the Rappahannock. 1863.

4. General U. S. Grant and Staff Officers, Massapomax Church, Va. May 21, 1864. Stereograph.

5. The Halt. 1864

6. Battery D, Fifth U.S. Artillery in Action. 1863.

7. A Harvest of Death, Gettysburg, Pennsylvania. 1863.

8. Quarters of Men in Fort Sedgwick. 1865.

Nevada, Utah, Idaho: U.S. Geological Exploration West of the 40th Parallel.

9. Sugar Loaf in Six-Mile Canyon, Virginia City. 1867.

10. Gould and Curry Mine, Virginia City. 1867.

11. At Work—Gould and Curry Mine. 1868.

12. Mouth of Curtis Shaft—Savage Mine. 1868.

13. "Intent on Duty," Ruby Valley, Nevada. 1868.

14. "Facile Decensus." c. 1868. [Clarence King, leader of the expedition, roping down a cliff.]

15. Mt. Agassiz, Unitah Mountains. 1869.

16. Shoshone Falls, Idaho. 1868.

17. Trachyte Columns, Trinity Mountains, Nevada. 1867.

18. August Snowbank, East Humboldt Mountains. 1868.

19. Salt Lake City & Wahsatch Mountains—S. Half. 1869.

20. Sand Dune near Sand Springs, Nevada. 1867.

Arizona, New Mexico: U.S. Geographical and Geological Explorations and Surveys West of the 100th Meridian.

21. The start from Camp Mojave, Arizona, September 15, 1871. Boat expedition under Lieutenant Wheeler, the first and only one to ascend the Colorado through the Grand Cañon to mouth of Diamond Creek. Distance traveled 260 miles in 31 days, the boats often having to be portaged around rapids and drawn over rocks. Stereograph.

22. Mountain transportation. Pack mule. Pack and Packers. 1871. Stereograph.

23. Black Cañon, Colorado River, from Camp 8, Looking Above. 1871.

24. Light & Shadow in Black Canon from Mirror Bar. 1871.

25. Wall in the Grand Cañon, Colorado River. 1871.

26. Aboriginal Life among the Navajo Indians, near old Fort Defiance, N.M. 1873.

27. Navajo Brave and his Mother. The Navajos were formerly a warlike tribe until subdued by U.S. Troops in 1859-60. Many of them now have fine flocks, and herds of horses, sheep and goats. 1873.

28. Navajo Boys and Squaw, in front of the quarters at old Fort Defiance, N.M., now unoccupied by troops. The agency for the Navajos is located here. 1873. Stereograph.

29. War Chief of the Zuni Indians. 1873. Stereograph.

30. Group of Zuni Indian "Braves," at their Pueblo, N.M. 1873. Stereograph.

31. Old Mission Church, Zuni Pueblo, N.M.—View from the Plaza. 1873.

32. Zuni Indian Girl, with water *olla*. 1873. Stereograph.

33. Pah-ge, a Ute Squaw, of the Kah-poh-teh band, Northern New Mexico. 1874. Stereograph.

34. Jicarilla Apache Brave and Squaw, lately wedded. Abiqui Agency, New Mexico. 1874. Stereograph.

35. Shee-zah-nan-tan, Jicarilla Apache Brave in characteristic costume, Northern New Mexico. 1874. Stereograph.

36. Canon de Chelle, Walls of the Grand Cañon, about 1200 feet in height. 1873.

37. Ancient Ruins in the Cañon de Chelle, N.M. In a niche 50 feet above present Cañon bed. 1873. [Now the Canyon de Chelly National Monument, Arizona.]

38. Rock Carved by Drifting Sand, below Fortification Rock, Arizona. 1871.

39. Historic Spanish Record of the Conquest, South Side of Inscription Rock, N.M. 1873.

40. South Side of Inscription Rock, N.M. 1873. [Now El Morro National Monument, N.M.]

The George Eastman House is indebted to the late Alden Scott Boyer for the gift of plates 1–8 and to Harvard University for the gift of plates 9–20, 23–24 to its permanent collection. The authors are indebted to Josephine Cobb, Jonathan Blair and Hermine M. Baumhofer for sharing their unpublished research.

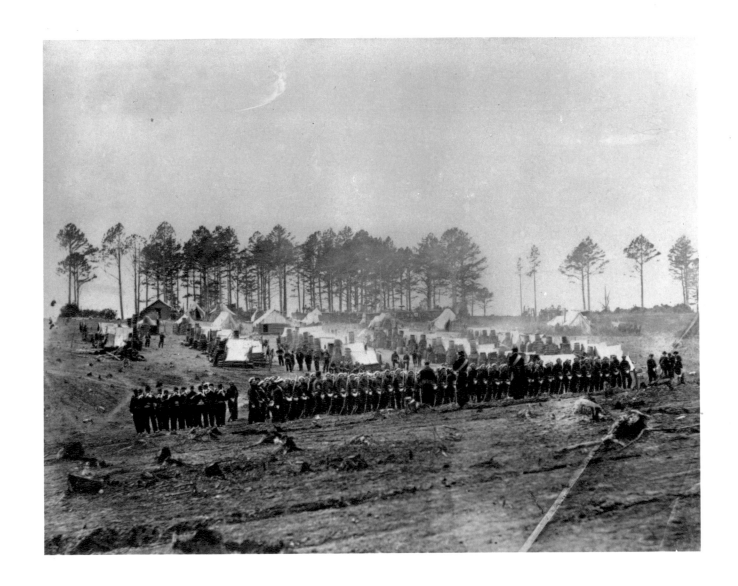

1. Headquarters, Army of the Potomac. 1864

2. Appomattox River. 1865

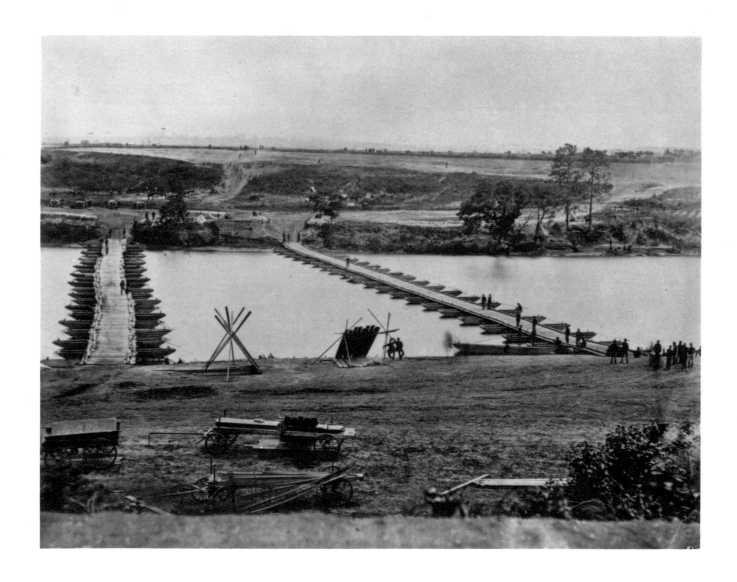

3. Rappahannock River. 1863

4. General U. S. Grant and Staff. 1864

5. The Halt. 1864

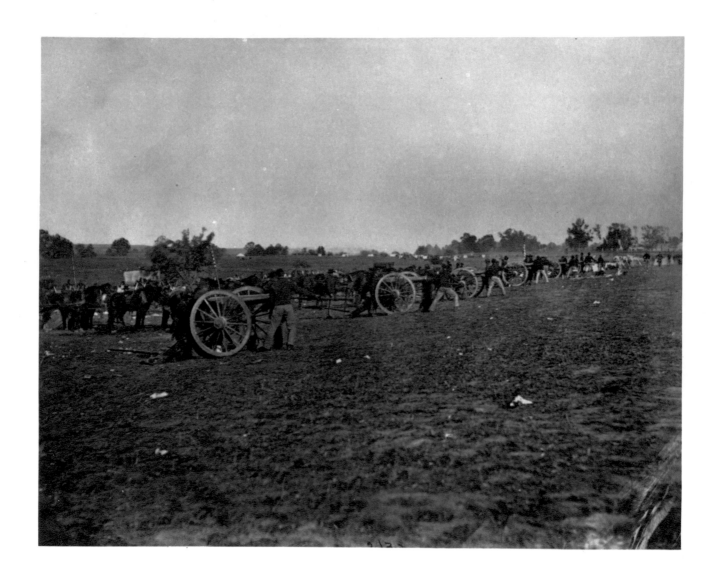

6. Battery D in Action. 1863

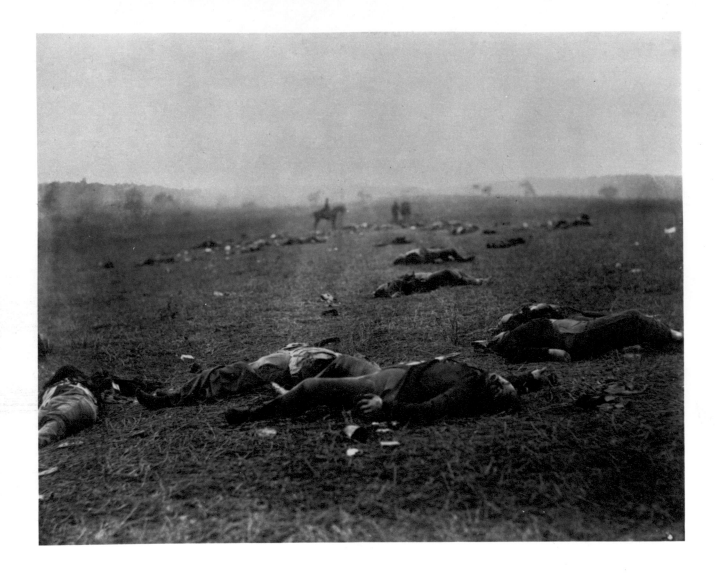

7. A Harvest of Death, Gettysburg. 1863

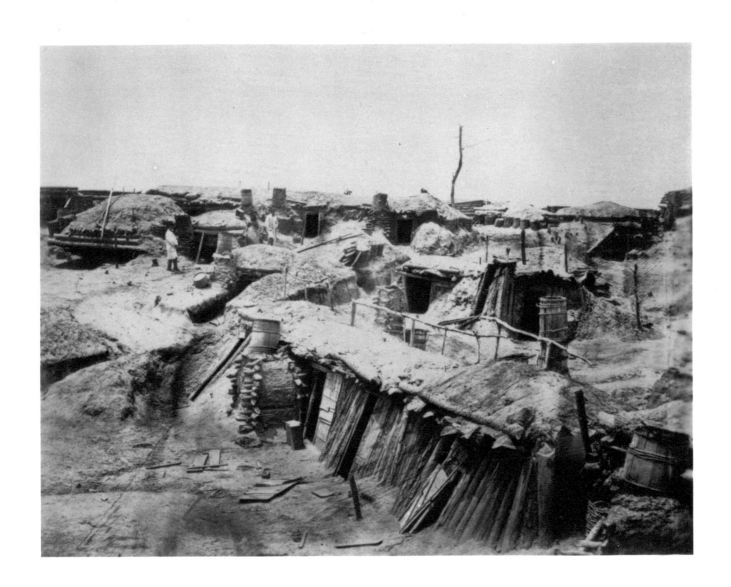

8. Fort Sedgwick. 1865

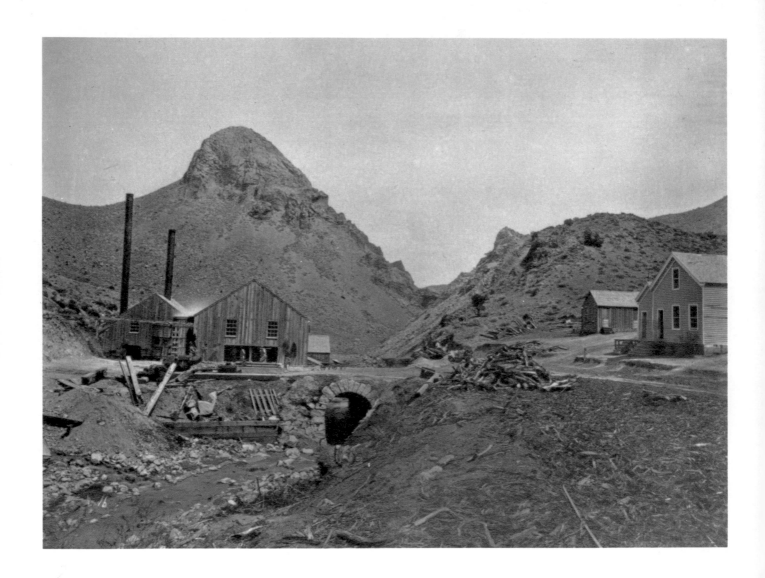

9. Virginia City, Nev. 1867

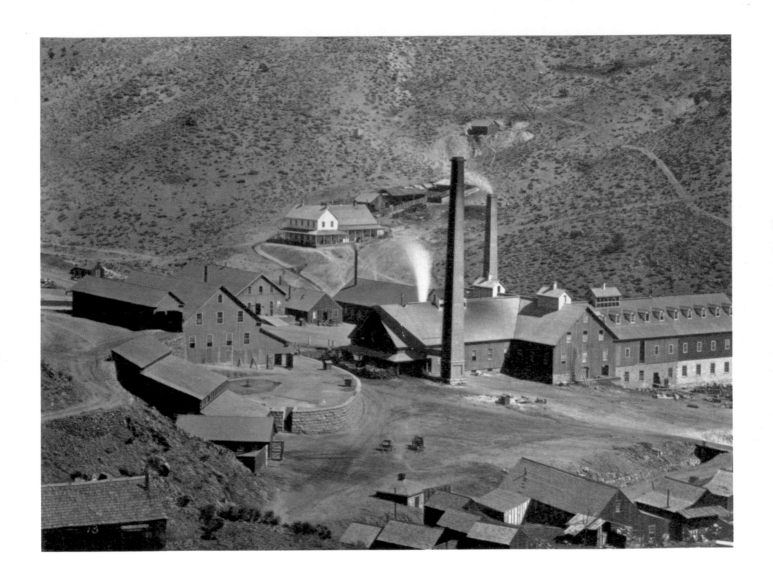

10. Gould and Curry Mine. 1867

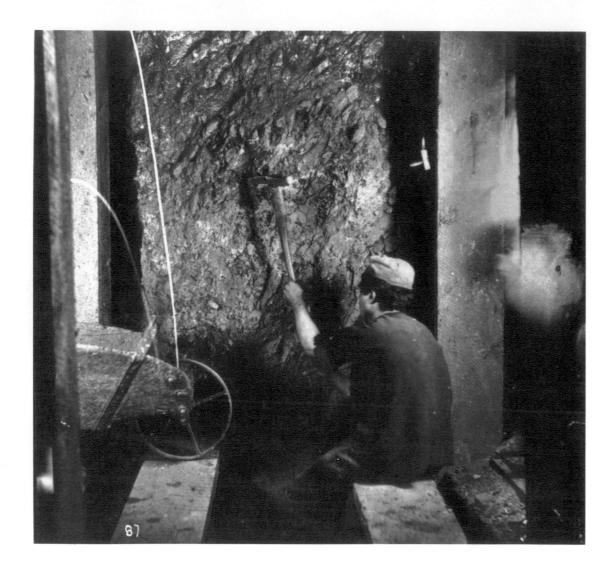

11. Gould and Curry Mine. 1868

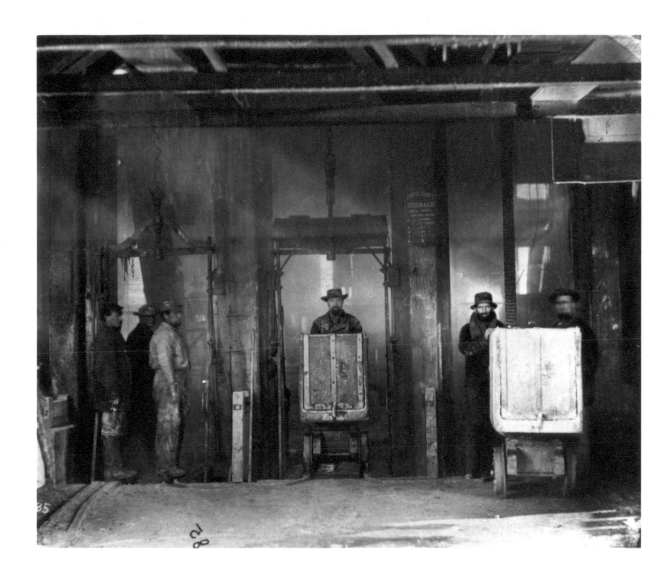

12. Savage Mine. 1868

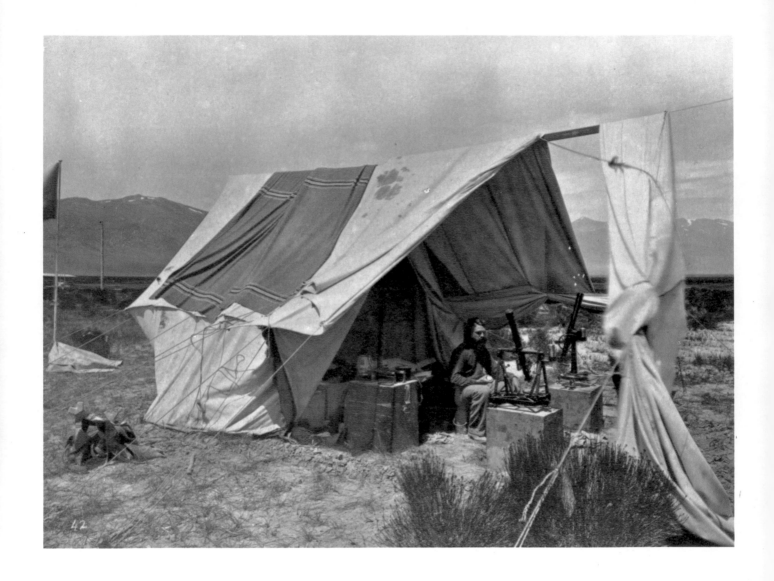

13. Ruby Valley, Nev. 1868

14. Clarence King. c. 1868

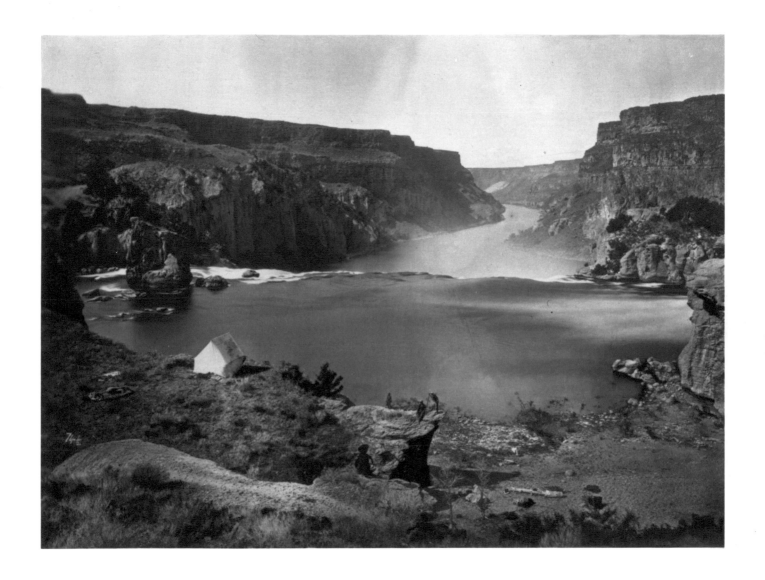

15. Mt. Agassiz. 1869 16. Shoshone Falls. 1868

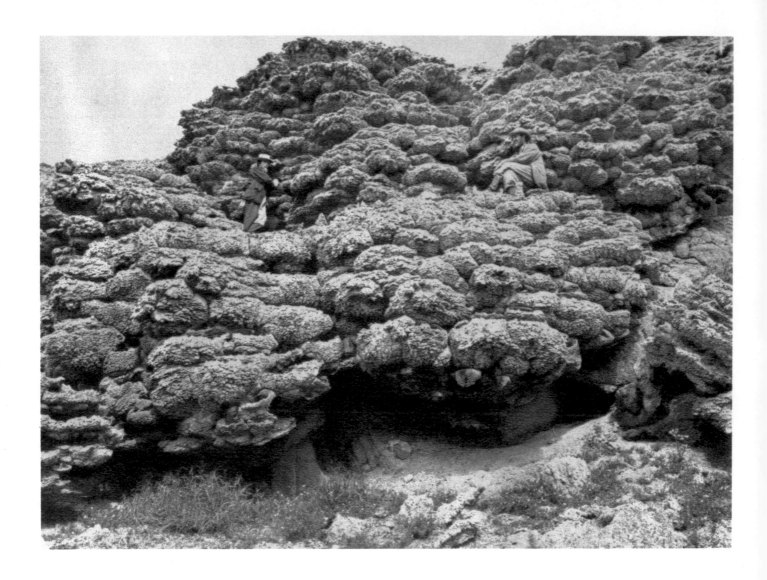

17. Trinity Mountains, Nev. 1867

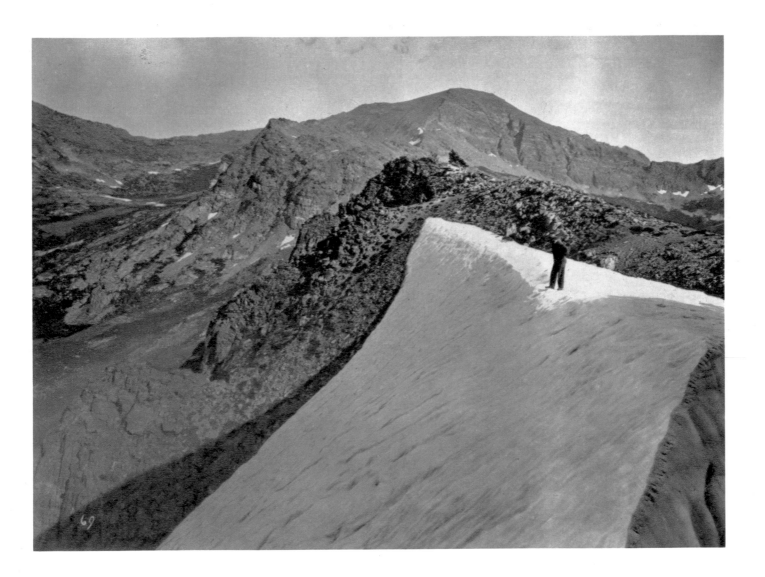

18. East Humboldt Mountain. 1868

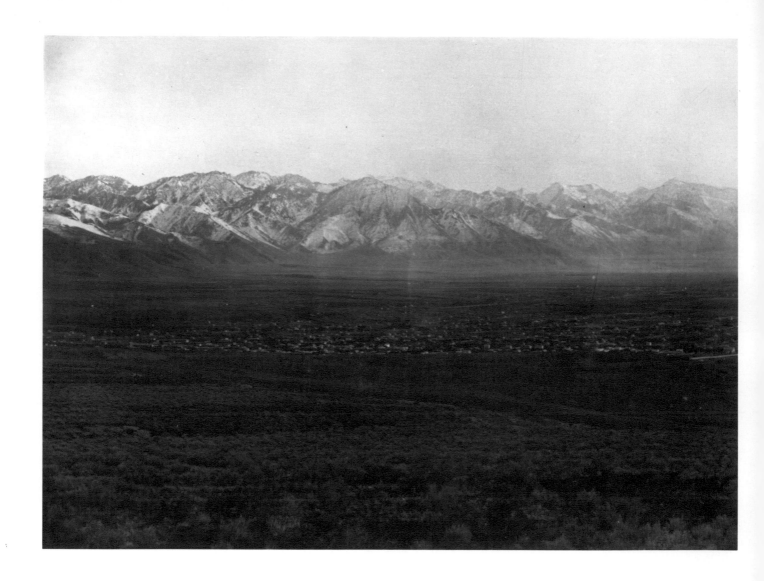

19. Salt Lake City. 1869

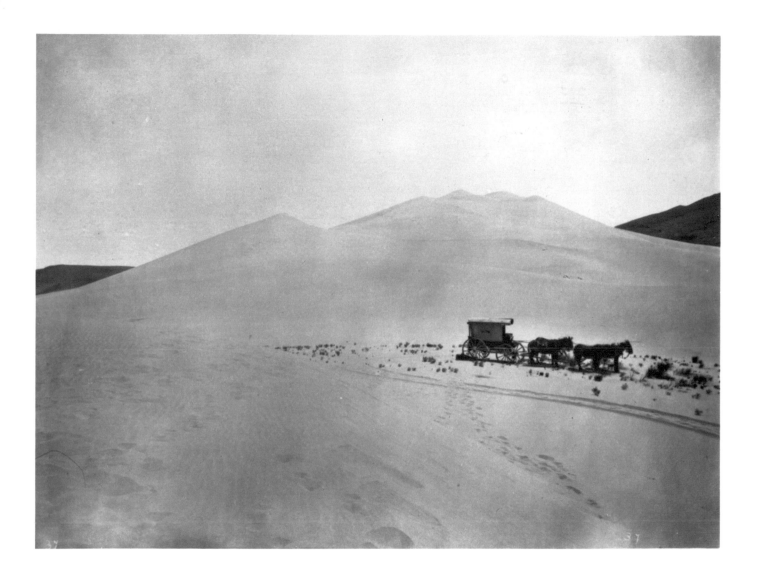

20. Sand Springs, Nev. 1867

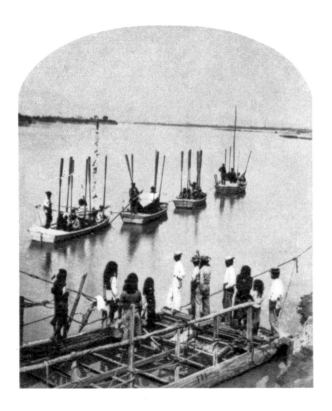

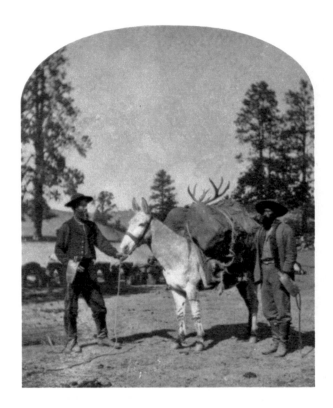

21. Expedition, Colorado River. 1871

22. Pack mule and packers. 1871

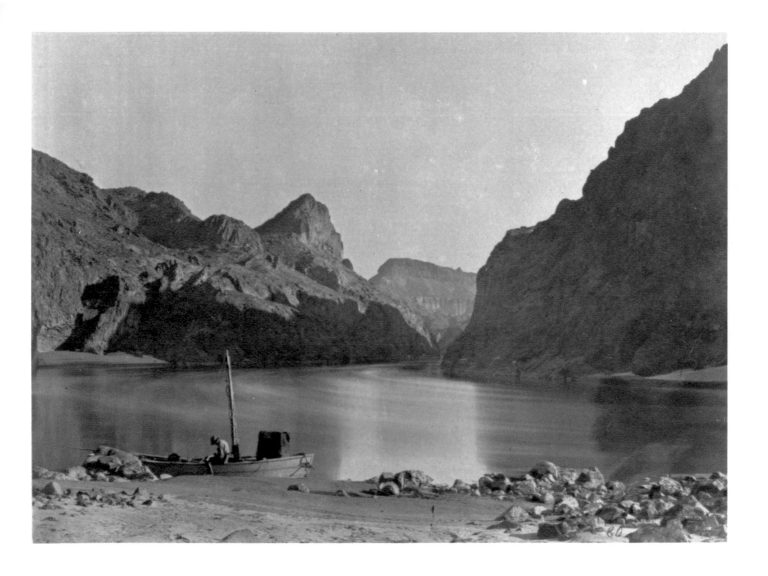

23. Black Canyon, Colorado River. 1871

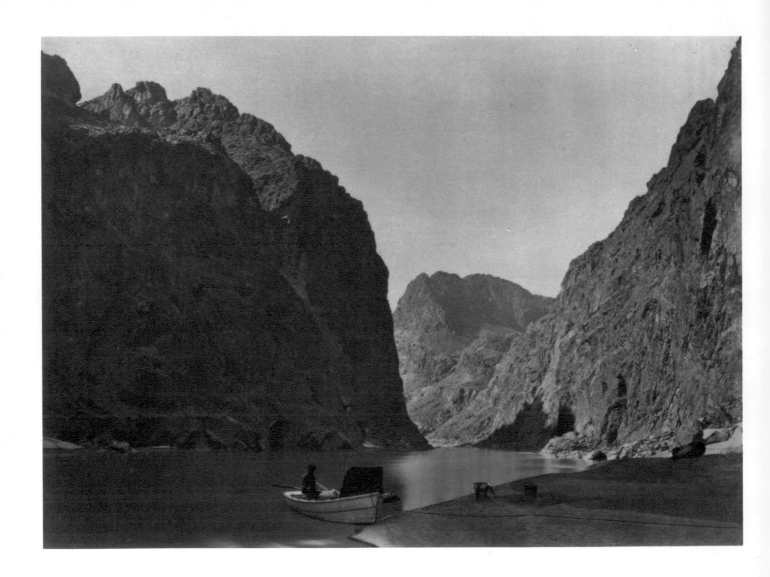

24. Black Canyon, Colorado River. 1871 25. Grand Canyon, Colorado River. 1871

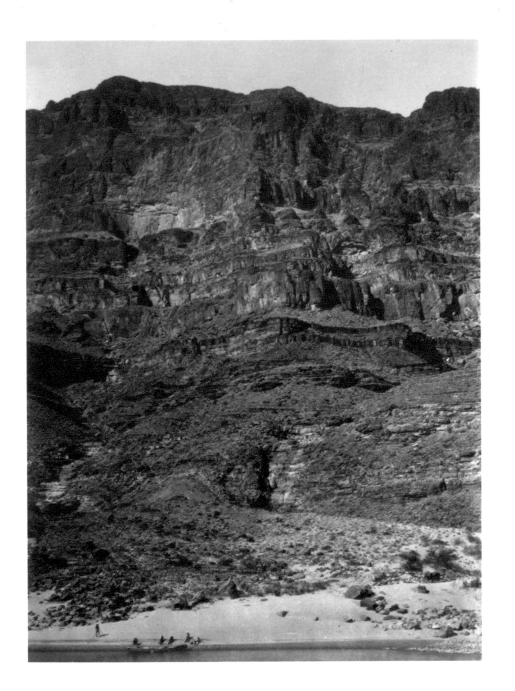

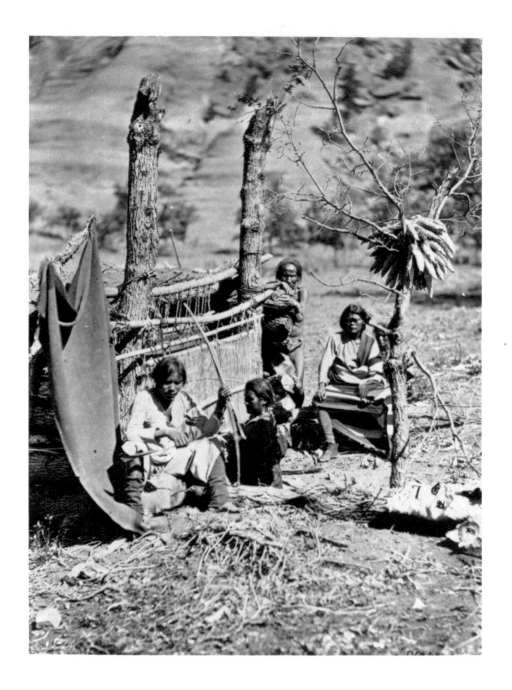

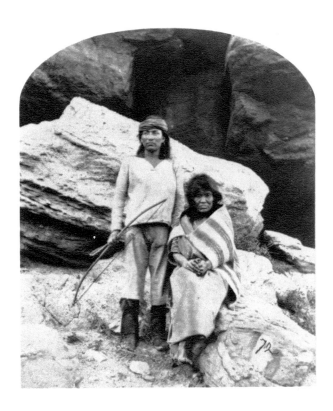 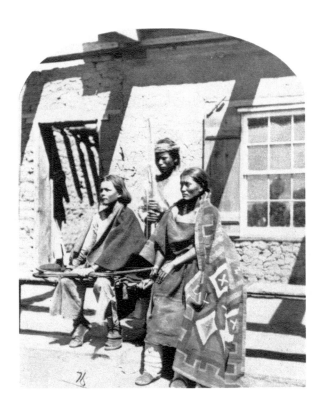

26.–28. Navajo Indians. 1873

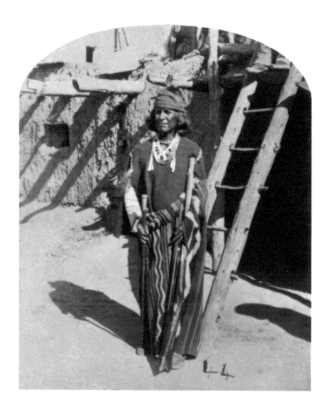

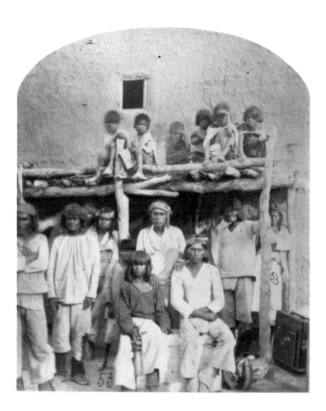

29. Zuni Indian chief. 1873

30. Zuni Indians. 1873

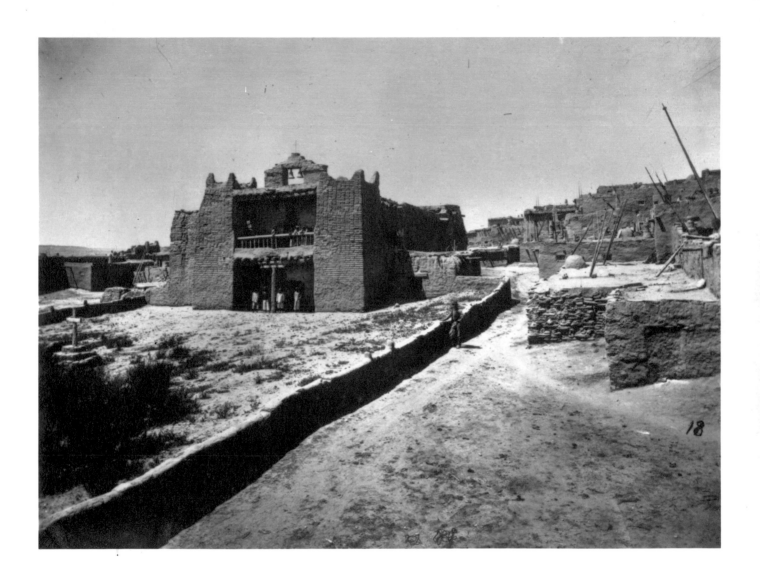

31. Zuni Pueblo, N. M. 1873

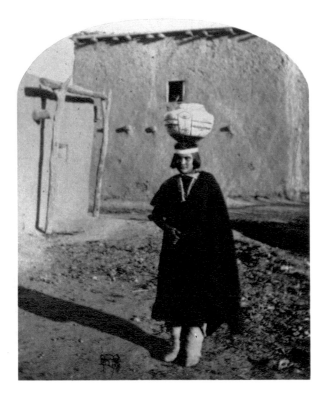

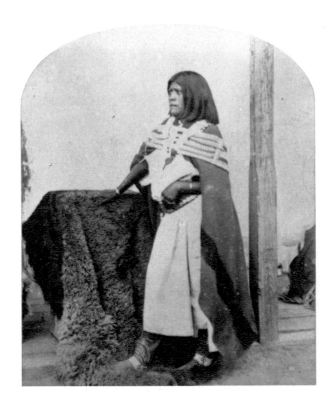

32. Zuni Indian girl. 1873

33. Ute Indian squaw. 1874

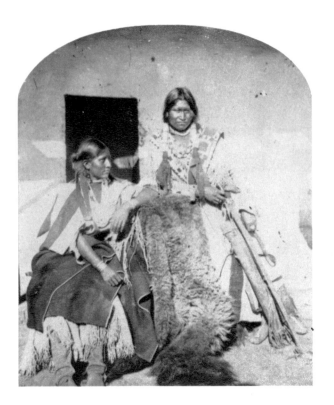

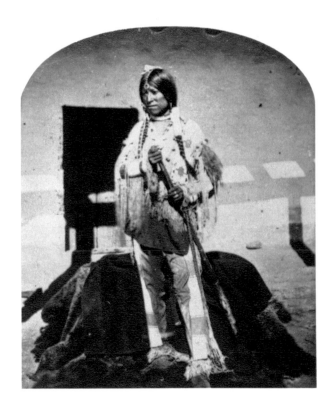

34. Jacarilla Apache Indians. 1874

35. Jacarilla Apache Indian brave. 1874

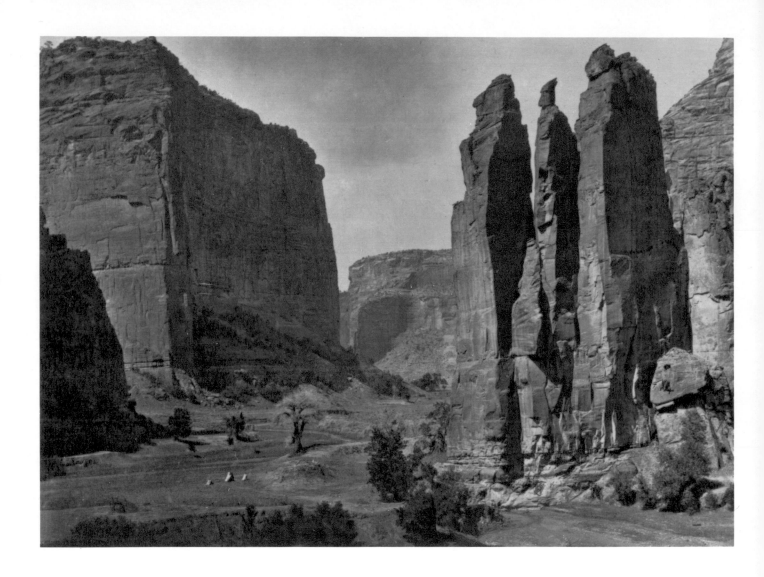

36. Canyon de Chelly, Arizona. 1873

37. Canyon de Chelly, Arizona. 1873

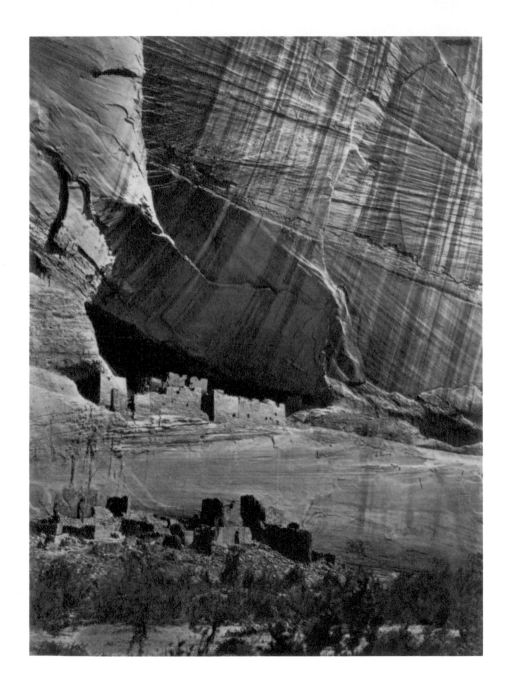

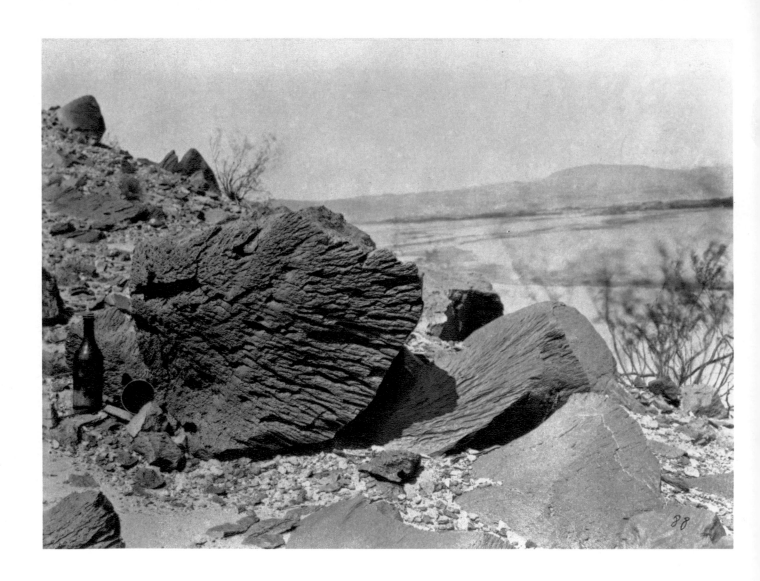

38. Rock carved by drifting sand. 1871

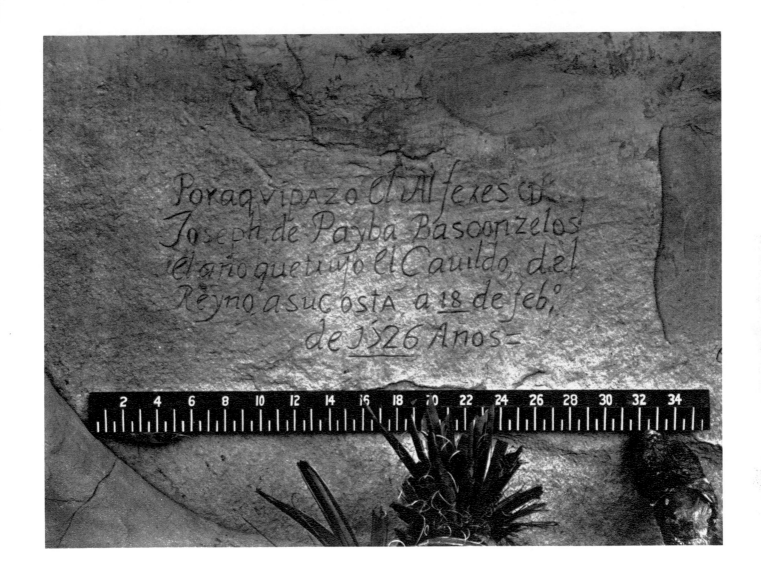

39. Inscription Rock, N. M. 1873

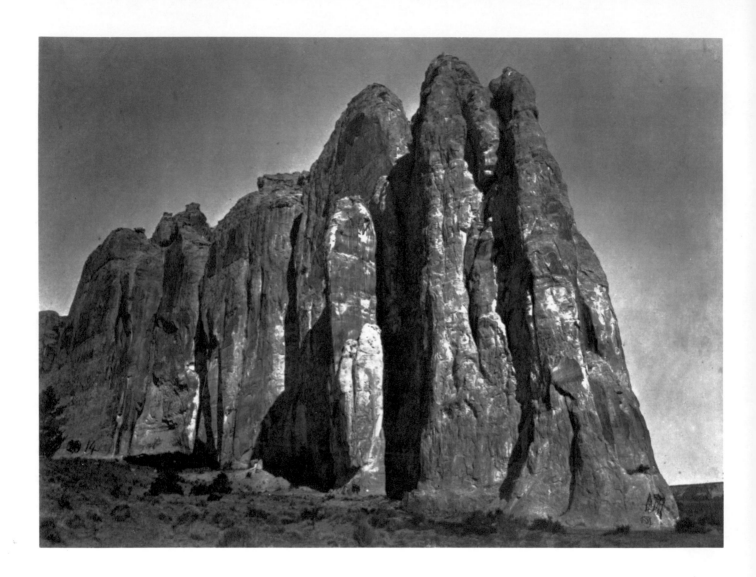

40. Inscription Rock, N. M. 1873

CHRONOLOGY

1840 Born in New York City.

1855 Meets Lewis Emory Walker, a photographer, and becomes professionally associated with him. Is employed by Brady. Works in New York gallery and then in Brady's Washington gallery under Alexander Gardner.

1861 Nov., photographs Civil War scenes in South Carolina.

1861 Dec., on staff of Brig. Gen. Egbert Ludovicus Viele, with rank of First Lieutenant.

1862 Feb., photographs in area of Beaufort, S. C.

1862 May, honorably discharged at Hilton Head, S. C.

1862 July, photographs in area of Manassas, Va.

1863 May, Gardner leaves Brady, establishes own business; O'Sullivan joins him.

1863 Sept., Gardner's catalogue *Photographic Incidents of the War* credits 166 photographs to O'Sullivan.

1864 July, photographs Gettysburg battlefield.

1865 Apr.-May, photographs the ruined forts.

1865 Gardner's *Photographic Sketch Book of the War* published, in two volumes, completed in 1866; 44 of the 100 photographs are by O'Sullivan.

1867 Leaves employ of Gardner. On July 1, joins U. S. Geological Explorations West of the 40th Parallel, led by Clarence King.

1868 Photographer on King Survey.

1869 Photographer on King Survey.

1870 Jan. 11, appointed photographer to the U. S. Darien Surveying Expedition; sailed Jan. 12 to Panama on U. S. S. "Guard."

1870 July 14, detached from the Darien Expedition.

1871 Photographer for U. S. Geographical and Geological Explorations and Surveys West of the 100th Meridian, led by Lieutenant George M. Wheeler: 300 negatives made.

1873 Photographer with Wheeler Expedition.

1874 Photographer with Wheeler Expedition.

1880 Nov. 6, appointed photographer to the U. S. Treasury Dept.

1881 March 31, leaves Treasury Department.

1882 Jan. 14, died in Staten Island. Cause: tuberculosis.

BIBLIOGRAPHY

Andrews, Ralph W., *Picture Gallery Pioneers*, Seattle, Superior Publ. Co., 1964, p. 12-17

Baumhofer, Hermine M., "T. H. O'Sullivan," *Image*, v. 2, p. 21, Apr., 1953.

Cobb, Josephine, "Alexander Gardner," *Image*, v. 7, p. 124-36, June, 1958.

Horan, James, *America's Forgotten Photographer; the Life and Work of Timothy O'Sullivan*, New York, Doubleday, 1966.

Newhall, Beaumont and Nancy, *Masters of Photography*, New York, Braziller, 1958, p. 38-45.

Sampson, John, "Photographs from the High Rockies," *Harper's Magazine*, v. 39, p. 465, Sept., 1869.

Taft, Robert, *Photography and the American Scene*, New York, Macmillan, 1938, p. 235-36, 283-88, 493.